JOKES ON THE SLOPES

With a Colouring in Therapy twist!

JOKES ON THE SLOPES

With a Colouring in Therapy twist!

ADULTS COLOURING BOOK

ESTHER LOFTUS GOUGH

authorHOUSE®

AuthorHouse™ UK
1663 Liberty Drive
Bloomington, IN 47403 USA
www.authorhouse.co.uk
Phone: 0800.197.4150

Published by AuthorHouse 11/30/2016

ISBN: 978-1-5246-6560-9 (sc)
ISBN: 978-1-5246-6559-3 (e)

Print information available on the last page.

Contents

Introduction

Esther is a Colour Therapist with an authors creative twist. She brings books to life with imagination and flair. A colourful reading experience becomes a fun, creative adventure, with a therapeutic COLOURING-IN twist!

Enjoy Esther's latest book and have a fun, creative, relaxing time colouring in.

Also use harmonious colours of the seasons to colour in a selected illustration.

In the Colour Therapy spectrum wheel, the Colours work opposite each other to create a therapeutic balance.

Winter

HARMONISING COLOURS

RED AND TURQUOISE

**History of
Skiing, hiking and biking.**

In days gone by,
Skied only the elite,
Nine Guineas London to Wengen,
A faddish fortnights treat!

With the sport more fashionable,
The fares then went up,
The 'Downhill Only Club'
Even sponsored a cup!

Wengen and Zermatt, the British frequented,
Lean forward, bend zee knees,
The lucky few knew what to do,
Wrapped well to avoid the freeze.

*Colour in Christmas Tree illustration
in harmonising colours
Red and Turquoise*

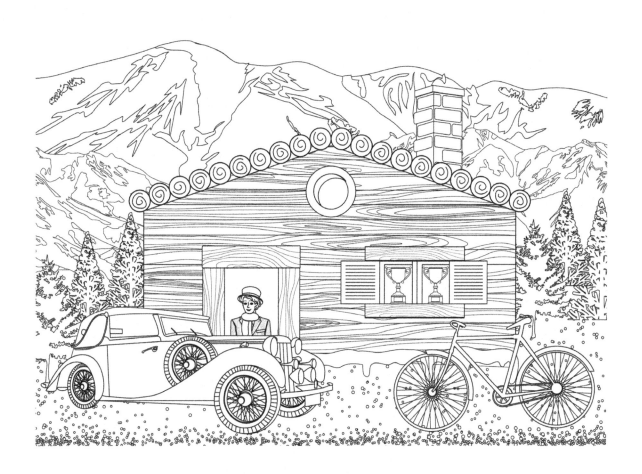

3

Spring

HARMONISING COLOURS

YELLOW AND VIOLET

SPRINGTIME

It's Springtime on the slopes
With much excitement and hopes
A cold winter past, will it last
With a summer of enticement and JOKES

DIET TIME

A diet is called for, the pasta is great,
My trousers have split, I'm so overweight.
My shirts bust with a Wang and a twang,
I'm so fat, I could explode with a bang!

The thought of a diet, won't make me groan,
It'll be steak and champagne –I'll need a loan.
After all my efforts, I hope it'll work,
If I don't lose weight, I'll feel such a jerk!

Colour in Butterfly illustration
in harmonising colours.
Yellow and Violet

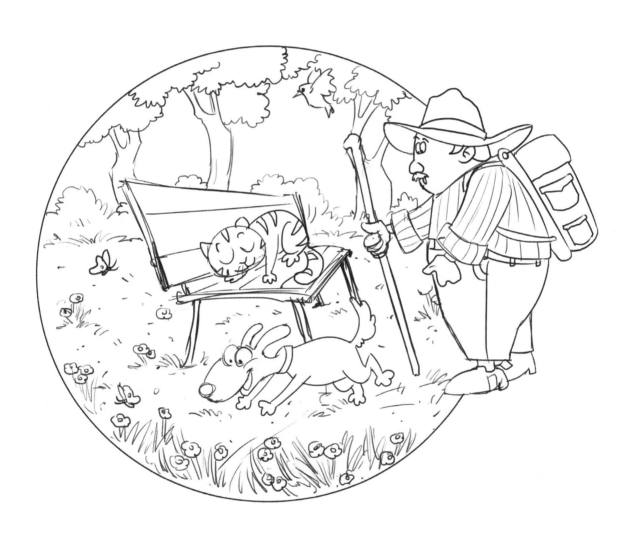

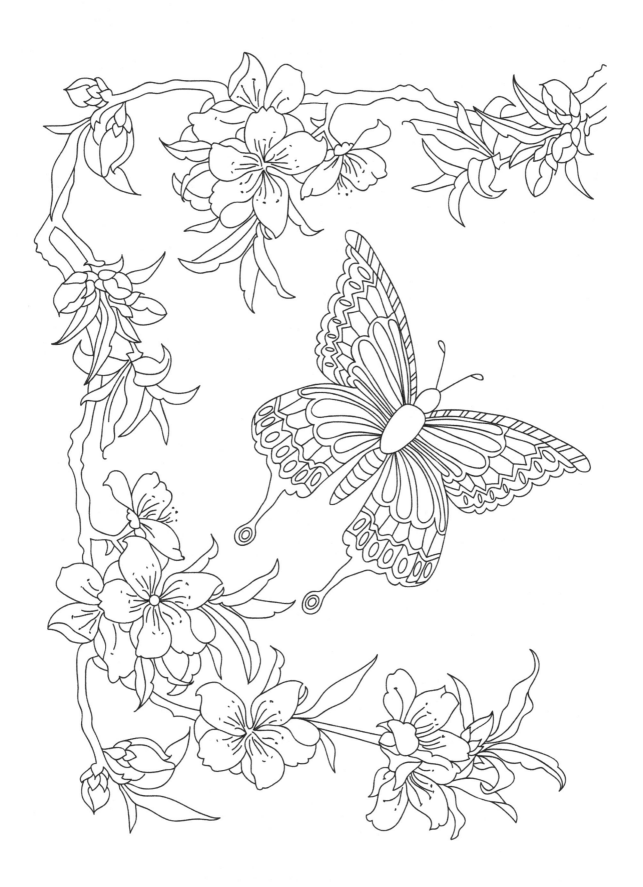

Summer

HARMONISING COLOURS

GREEN AND MAGENTA

HIKERS AND BIKERS

Hikers arrive, tired and weary,
Geoff and John, eyes bleary.
Come in, relax-Where's your bike?
Are you cycling today-or on a hike?

Supper is served, banana soufflé hot,
Seconds for Geoff, Wow he's devoured the lot.
What's he got, I haven't? chants a guest,
Is he loaded or have I paid less?

Colour in Flowers in pots illustration
in harmonising colours
Green and Magenta

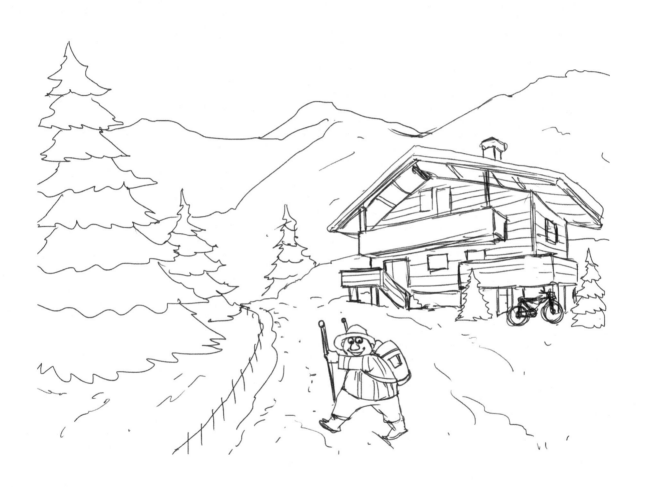

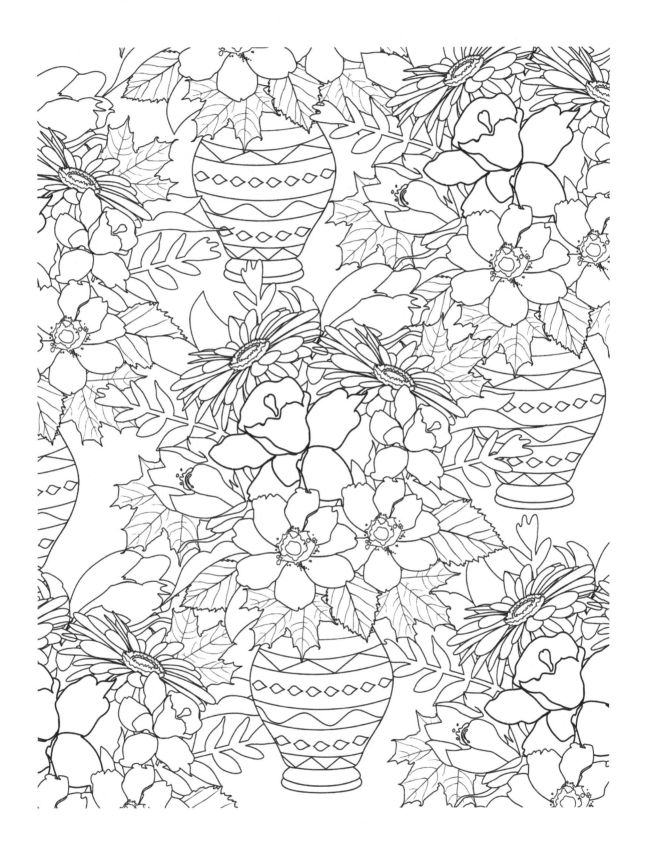

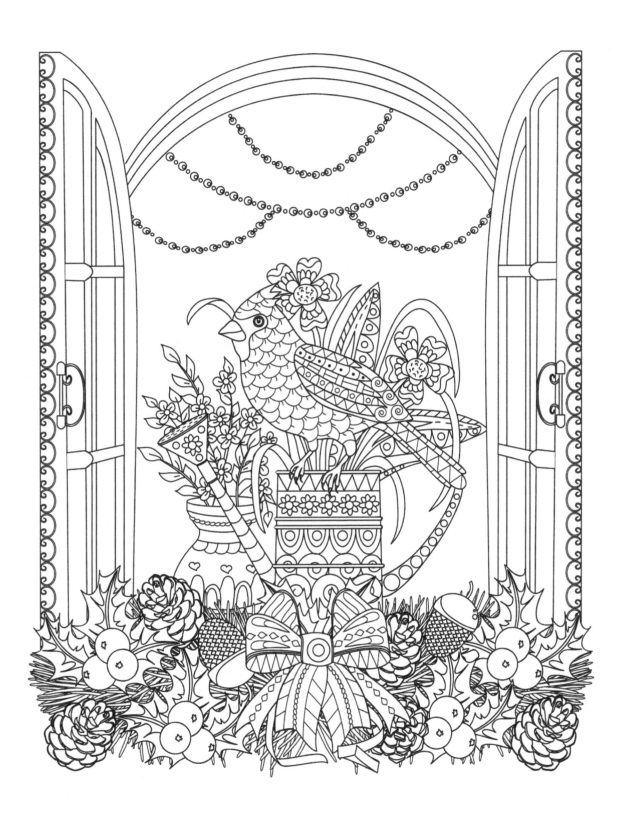

23

Autumn

HARMONISING COLOURS

ORANGE AND BLUE

FONDUE TIME

The Fondue evening is a must,
George hits the schnapps,-ogling with lust!
Gruyere, Emmental, Kirsch, hot in a pot,
Let's go for it big time -Why ever not!

Hot potatoes, squares of bread,
Onions and gherkins, we're watered and fed.
George pipes up- what's next on the agenda,
What more wine? This really is a bender!

BACKGAMMON

Whilst playing Chess or Backgammon,
Tom drinks Champagne and eats smoked salmon.
I'm no good really, why not have a game?
I haven't played for ages- we're told over and again.

The challenge is taken by Tony,
He knows he's not an ace, but
Toms bragging is hard to carry,
Wonder who'll end up red faced!

*Colour in Mushrooms illustration
in harmonising colours,
Orange and Blue*

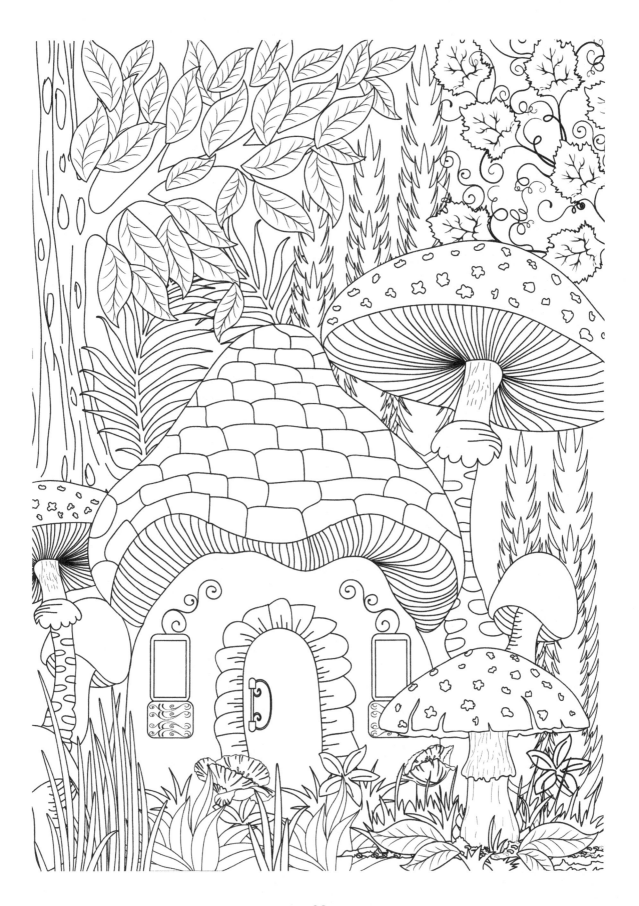

29

Biography

Esther was born in Australia, but has lived in England from the age of 6. Having a grandfather who wrote historical, educational books, Esther was bought up with storytelling as an everyday added bonus. Esther attended The London College of Fashion and has always been a storyteller, but only decided to be published recently having decided to add the Colour Therapy twist.

With the Colour Therapy element comes a fun, colourful, educational, flow of words.

Useful for learning disabilities, including dyslexia.

Esther is the author of;

BLUE IN THE TOOTH, Teeth hygiene with a Colour Therapy Twist!
(ENGLISH AND ARABIC TRANSLATION)

AUNTIE BERTIE AND THE FLYING CIRCUS MOUSE,
With a Colour Therapy Twist!

http://www.colourtherapytwist.co.uk

www.youtube.com/user/esthersuz

BUY ON AMAZON
www.amazon.com/author/estherloftusgough

GROPES ON THE SLOPES! Out soon!

COMPETITION FOR BEST HARMONISING ILLUSTRATION -
Take a look at www.colourtherapytwist.co.uk

Printed in the United States
By Bookmasters